# Illumination

**tarcher**perigee

an imprint of Penguin Random House LLC
penguinrandomhouse.com

Most TarcherPerigee books are available at special quantity discounts for bulk
purchase for sales promotions, premiums, fund-raising, and educational needs.
Special books or book excerpts also can be created to fit specific needs.
For details, write: SpecialMarkets@penguinrandomhouse.com.

Library of Congress Cataloging-in-Publication Data

Names: Gregson, Tyler Knott, author.
Title: Illumination: poetry to light up the darkness / Tyler Knott Gregson.
Description: New York: TarcherPerigee, 2021.
Identifiers: LCCN 2020020372 (print) || LCCN 2020020373 (ebook) ||
    ISBN 9780593191361 (hardcover) || ISBN 9780525537557 (ebook)
Subjects: LCGFT: Poetry.
Classification: LCC PS3607.R4965 I45 2021 (print) || LCC PS3607.R4965 (ebook) ||
    DDC 811/.6—dc23
LC record available at https://lccn.loc.gov/2020020372
LC ebook record available at https://lccn.loc.gov/2020020373

Printed in the United States of America
1st Printing

Book design by Laura K. Corless

1 3 5 7 9 10 8 6 4 2

# Illumination

Poetry to Light Up the Darkness

TYLER KNOTT GREGSON

A TarcherPerigee Book

sly

# Introduction

Some roads in this life are straight, arrows that fly true and never wobble. From the start, if you look hard enough, you can see exactly where they'll end up. Some roads are smooth, sun-soaked, and lead to only beautiful destinations. Some, are not.

Sitting here, looking back at the roads I've wandered down to get to this point, I can say with confidence and a quiet melancholy, I've never been on a straight road, I wouldn't know what to do with all that sunlight if I happened into it. All these roads were winding, all those days knew storms, whether they were bookended by them, or soaked the whole way through. Sitting here, I can say with what I can only call wisdom, and fresh understanding, that all I am and all I have is because of this, because of the darkness that found me, because of the twisting paths that seemed to never end.

*Chasers of the Light* began this journey, introduced my obsession with finding all that shine in all that dark, and showed the world the strange way my brain sees it. *Wildly into the Dark* dove headfirst into

that darkness, showed myself, and hopefully the readers who took a chance on it, how much beauty can exist in sorrow, in the murky seas so many try to pretend don't exist. With *Illumination*, I truly believe I've come full circle and am chasing that same light with a new, deeper, and more passionate intensity. *Illumination* is all about the light I've been chasing, the glow I never stopped believing existed on the fringes of every shadow, it's about showing it to you, whoever you are, whyever you need to find it.

Only when I broke, did I become whole.
It was the pieces, sharp edged
but ill-fitting, that I needed to see
spilled out before me; some pictures
only come into focus here, in a shattered
space.

These are words about something.
These are sounds that stand.
There is music in a broken heart.
There are lyrics to this sadness.

Perhaps this is an old theme, revisited
too often, written too much. Perhaps
I come here when I am lost, the
unforgettable path my feet have tread
a dozen times and a dozen more.
There is memory to muscle.

If I knew the way, I would end this
in a new fashion. I would surprise
and delight and you would end this
recitation with a jaw freshly dropped
to the floor. If I had a voice I'd sing them,
for there is music in a broken heart.

There are lyrics to this sadness.

I have walked dark roads,
and those who know me, know.
Seen clouds rumble forth,
seen them shade the sun,
steal what was left of warmth,
I know what it is to shiver.

I am intimate with empty hands,
and those who've held them, know.
Reached into hollow air,
muscle memory I call it,
and laugh off these fingers
made fist.
I know what it is to ache.

I sing the songs of gratitude,
and those who've heard me, know.
I know time as an unpromised thing,
some star that shines only
when you turn your face from it.
I know what it is to peek.

I am studied in the art of waiting,
and those who taught me, know.
That one inch by one inch,
the mystery of life feathers out
until faded, that all things ease.
I know what it is to endure.

I know of light that rises,
pulled skyward as if metal
and something bigger than me
is magnetic above.
I know what it is to call myself
light.

Will I leave here and say it was filled,
up to the brim, meniscus at that
delicate spot before filling
becomes spilling over?
Was this a life spent well,
time deposited where
time belonged, did I
laugh enough along the way?

I know more of failure
than success, I know this,
but I know more of
standing back up
because of it.

We'll see where the dust settles,
we'll see what gets left behind.

Careful with those
who would rush
your healing,
who would point
to their
watch
and remind you of time's
passing.
This thing takes time,
there is no shame
in going
slow.

Ain't nothing
you can't carry,
no burden too heavy,
no ache too deep.
You're the ferocity
and shout into the dark,
you're the rising type,
lifting higher
above the canopy,
high enough
for the light
to reach.

There's no plan for this, these waters
are uncharted.
We were ships that sailed together,
close enough to reach across,
we knew the knots to moor
as one, didn't we? We knew all
there was of the open sea
and the mysteries beneath it.

Now, we of the landlocked and forlorn,
shout across the valleys
to one another,
make friends with our echoes
as miles stretch out like lazy
animals in some patch
of sunlight.

Light the lanterns and keep
screaming into the darkness,
watch the spark spread
across mountaintop and glen,
stars stuck earthward,
lean your ear into the void and
listen for the howling
of all those lost and alone
just like you.

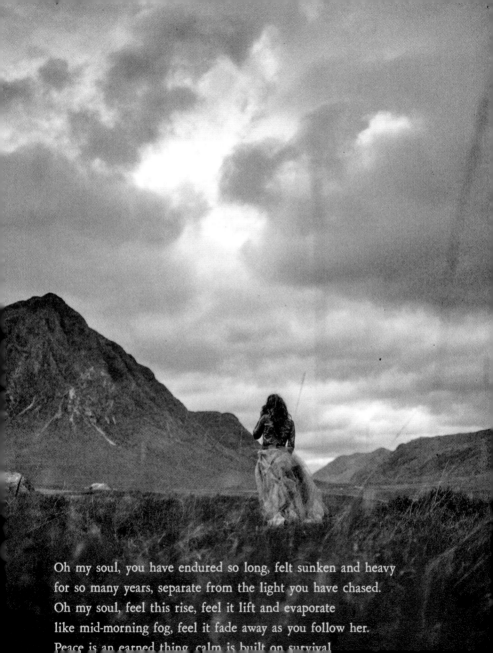

Oh my soul, you have endured so long, felt sunken and heavy
for so many years, separate from the light you have chased.
Oh my soul, feel this rise, feel it lift and evaporate
like mid-morning fog, feel it fade away as you follow her.
Peace is an earned thing, calm is built on survival

Explanations don't provide the justice,
don't illuminate quite effectively enough,
something more is required,
and so it's sought after.

Each morning there is a climb,
there is a xxxxx truth, released like magic
dove after years  of black hat
service.  Each morning a climb
from some dark depth within myself,
hand over hand, a ropeless journey
up and over and across,
the only destination is up,
is out.

I have known this place all my life,
decorated it as home this silent
space, never invited anyone in.
This is a host-less place I say,
there, another truth.

I will find my way to you,
hands and dried blood,
shaking but strong.  It will
take time, and tomorrow
I will need to do it all over
again,

but I will come back up
for you.

There, a final truth.

Some pain comes, but
does not go;
some guests overstay
their welcome.
I've a nomadic camp
inside me, always moving
but never fading
away. When it all
falls quiet, I can smell
the smoke
from their fires.

Fall away with me,
into
the wild places,
where the darkness
lives,
where maps run out.
Be afraid
if you wish, if
you must,
but come,
all the same.

You will find home there,
you will
remember
how to love.

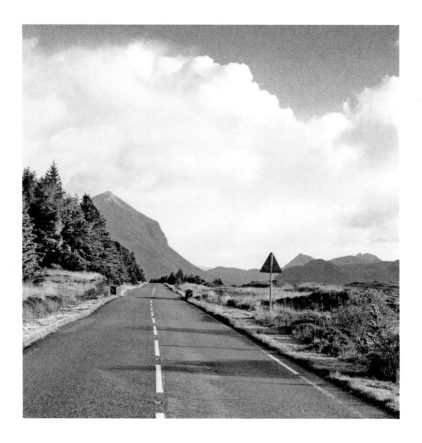

New days mean new roads. New roads mean new choices,
new choices mean new versions of ourselves every time we choose.
This year, this time, let's resolve to be braver, more adventurous,
more open to being transformed by this beautiful world.
Let's explore more and worry less, say more *I love you*s
and have less reason to say *I am sorry*. It's time to wander out
into the wild spaces and, in doing so, meet ourselves again.

What a waste, comparing yourself,
looking for your life
in theirs, where they line up,
how far ahead, keeping score.
Cut the cords to those
that burned you, stop holding
anchor ropes, stop building calluses
on those hands.  They are at home
on my skin, leave them there.

We aren't them, we won't be,
not those that hurt us, not
those that left us behind;
we're not them, we shouldn't be,
not those that test patience
or boil this blood.

Let them live how they wish
to live, let them stay that way.
Our revenge,
will be this
love.

I've had knuckles bruised
from the belief that I could
punch it away,
I've had blood running down
 fingertips, from all the days
it hurt too much to
feel.
It stayed, the punches didn't
matter, it stayed,
when the slices
became scars.
It was breath, in the end,
that brought about the quiet,
slow breath through shaking
lungs.
We are worth enough
to stay.

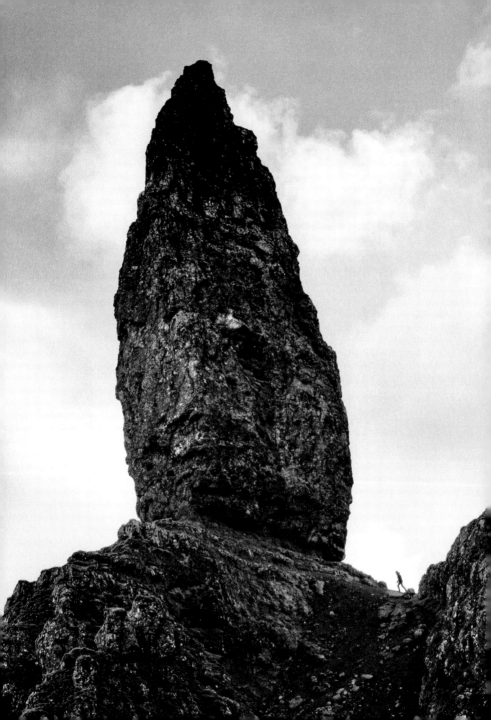

There's gonna come hills, mountains we have to climb up and over, it's gonna be hard. We're gonna ache, legs burning and lungs alight, we may want a rest, may want to turn it all around and call it a day. I promise you this: I will keep going forward, I will keep walking, keep aiming up, keep glancing over my shoulder to make sure you're there. I will keep going. Always.

Rubble,
this a land of rubble.
We are what comes after
collapse, but the kind
unadmitted.

I tell myself there is hope
in fire that spreads,
that we are seeds
that open in heat.

I hold this tight to chest,
feel it beat like a
second heart.

I believe, there is
tenderness
amidst the flame
and ruin.

—

Like window
after winter
long,
like breeze
clearing air of
stagnation
and dust,
fresh air to usher
off and out
the stillness that
settled,

open this heart
for it is
hinged,
and let in
the gust
of hope,
the warm current
of love.

I wait through the freeze
for the fire,
then wait through the smoke
for the frost.
Burned or frozen, sizzling
or stiff, I wait, and look for
beauty in the both.

For it is there,
it is every bit of
every
where.

Wings in the white,
diamond dust
and light pillars
rising into the black.

Wings in the grey,
plumes billowing
like explosions lifted.

It is here.

Everything changes,
one thing to another
some from growth
some from destruction,
some from the abandonment
some from the viral spread
of hope.

Winged
was crawling once,
flame
was frozen fingers and
held breath
and death waiting
in the shadows.

There is no end
to this, everything
changes.
Call it halfway
and wait for
transformation.

Robert A. McKinnon

450
R

If I wrote it on your hands,
tattooed it permanent
in stuttering script
would it remind you, would it
replant the seeds you dig up?
If you saw it, as fingers go
to face in the routine of each
morning, would you recite it
as gospel, and believe it
with faith?

You as you are,

written in ink sunken
beneath left palm
and fingerprint

enough

plain and true
on the right.

Wouldn't you shout out loud,
wouldn't you dance
and forget the shyness,
wouldn't you rejoice and
worry not the words you
screamed?

Do you know how long I rotted
on that desolate road,
do you know how close I was
to forgetting all the whys?

I've got a voice for hymns now,
gospel songs sang
to that god I call
survival.

Joy is an arm full of old scars
with blood settled and safe
beneath the surface,
blood that knows
it made it through
the Winter.

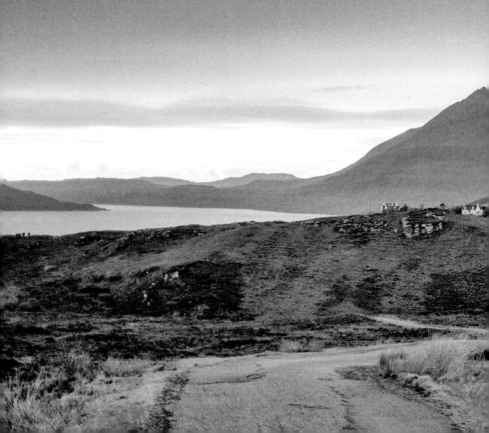

Here's to waking before the sun, and boarding the flight
before the dawn. Here's to breakfast at home, then a dinner far,
far from it. Here's to feet that won't stop exploring,
to the stories you'll tell, after earning that right.
Here's to the storm clouds and sunny days, the green, the grey.
Here's to the roads you'll adventure down, whichever side
you're told to drive on. To the serpent of asphalt that leads to
all those somethings you have always imagined.
Here's to the wanderlust.

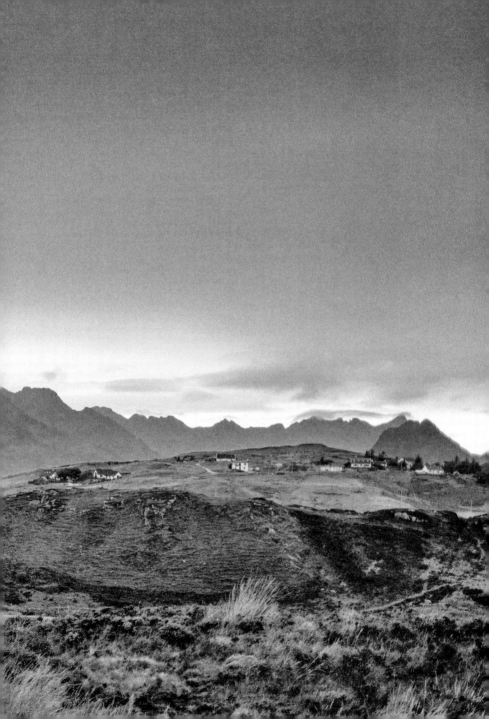

Make me a servant to your cause,
teach me how best to help,
where to place this privilege,
where to invest any strength
I may have. If you need me not,
tell me this and I will watch
with mouth open and awe
on my breath, at the world you
save.

I am here for any use you
put me to,
I am here with words and
love, if there is nothing else
I can do.

Lumpy bed slanted left, rolling me
toward the window, jammed shut over
a radiator that won't shut off.
Tiny television with four channels,
three blurry, one always the news.
Twelve dozen stairs that creak,
long hallways that undulate
like waves, two thousand faces
my eyes have never seen.
Conversation that emerges
from nothing, and grows like
it was watered, realization that
things are shared, despite the sea
that splits us.  Sunrise over
a landscape brand new after rising
in the middle of the darkness
forgetful of where you are, trying to
map the room to remind yourself,
sunset over cobblestones and
corner cafes.

This is why we go, travel
is the reminder that we know
so little, but are willing to learn
so much.

This is why we go.

Fascinated by the shadows
in me,
the dark patches of soul
most shy from,
the caverns below
the gardens,
the mists that remain
when the rain has gone.

Here,
I am made whole again,
eternal spring of
immortal persuasion,
here is the source
of the life that comes
from mind to heart,
heart out to voice,
to fingertip,
to ink.

I am not the sun,
I am the shade
and the cool earth
it falls upon.

Be here,
with eyes wide
and hands still
at your side,

capture this not,
leave it
for the old film
of memory,

let it grow,
then fade, then
bloom again
when your mind succeeds, briefly
in a sea of
forgetful failure.

Stay here,
and see what
there is to see,
let these moments
remain uncaptured,
free.

                    Gregson—

I kept going,
every time I wanted to quit,
every time I thought
my heart would give out.
I kept going,
when hands bled and my voice
ran off in search of
peace. Self-preservation,
it whispered,
the final sounds I heard it
say.
I kept going,
when darkness crept,
found me hiding in the last
slivers of the light.
I kept going,
I am still
here.

Where do we bury
the bones of our dreams,
what graveyard, what headstone
marks the resting place of our passions?
We mourn them, often when their passing
is fresh, flowers on the upturned earth.
We marvel as it settles, shovel stabs
healing as if stitched, grass returns.

We forget, we're built for this,
the amnesia that keeps us alive,
forget to recall what it was we buried,
forget who we were before the loss.

In some fever dream of night
we sit straight up with voice hoarse
from the shouting.
Haunted, we say, and hear the
whisper of what we entombed.

Grab our shovels and unsettle the earth,
dig until you hit wood and regret,
dig until mud soaked and sobbing,
dig until that whisper becomes a scream.

Do not mourn what can be revived,
pound on the lid you hid them beneath
and shake the bones of your hope.
Call this excavation, call it exhumation
and with all you sacrificed,
run off into the still night air.

What of thorn, what of bramble, what of poke?
What of drought, what of torrent, what of fire, what of flood?
Oh what of life, what of bumble, what of blossom?
Oh what of green, what of color, what of scent, oh what of bloom?

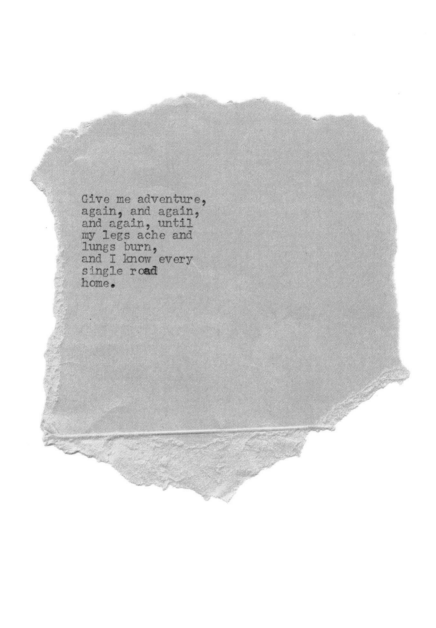

Give me adventure,
again, and again,
and again, until
my legs ache and
lungs burn,
and I know every
single road
home.

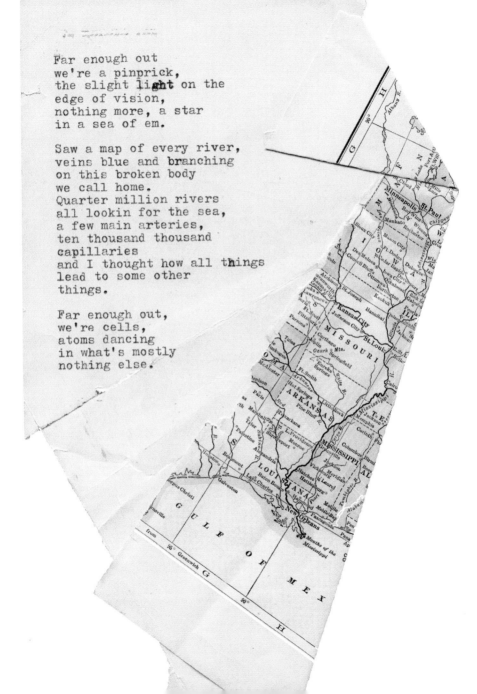

Far enough out
we're a pinprick,
the slight light on the
edge of vision,
nothing more, a star
in a sea of em.

Saw a map of every river,
veins blue and branching
on this broken body
we call home.
Quarter million rivers
all lookin for the sea,
a few main arteries,
ten thousand thousand
capillaries
and I thought how all things
lead to some other
things.

Far enough out,
we're cells,
atoms dancing
in what's mostly
nothing else.

To be there to see it,
the wings of geese in the lightlessness,
the blur of hummingbirds roaring
softly on summer porches,
the earthquake of thunder
on evenings when you swear dusk
will never fade out.
Be for this,
keep being, for there is music
in all this,
quietly it plays, almost inaudible,
but the melody remains.
Be for this,
and lend yourself to the
perfect cacophony.

It's exhausting
being strong, let no one
tell you otherwise,
there are a million ways
to heal,
every single one
will wear you down.

Keep your capacity
for joy,
guard it
with the rest
of your
life.

-Tyler Knott Gregson-

Seek I shoreline,
seek I mist,
the absolution from
the weight I carried,
the silence I deserve.
Seek I mountaintop,
seek I rainfall,
the peace of a vanishing,
the stillness
granted like mercy.

Seek I green on grey,
seek I empty road,
the echoless places
cradled in cloud and soil,
the steam rising from
single lane blacktop,
cracked but steady on.
Seek I hush,
seek I darkness,
as eyes close in calm
and fresh air finally
floods these
lungs.

One day, I'll climb taller mountains, fade off
into the thin air of some forgotten place,
find peace in silence and the repetition
of some routine, sweep the same floors
over and again and understand it was never
about the dirt, at all.

I'll swim deeper seas, rise breathless
and bursting, craving air above all things,
learn of emptiness that threatens
from the darkness below, that it's light
near the surface of your own salvation,
that you'll be choking when you arrive.

I will sit hungry and watch others eat,
ask not for plate or cup, but delight
in satisfaction that swells in others.

I have more to learn of this place,
of what it is to worship what deserves
worshipping, of how to be something
worth digging back up when I have
stopped, of being ashes
worth spreading into some stiff
Eastern wind.

Sometimes you gotta leap, take a jump into the unknown
and hope for the best. Sometimes you've been perched
so long you forget your wings, forget the songs you were handed
down, the songs you once sang. Sometimes you're stuck and frozen
in fear and worry and the weight of what if.
Sometimes it takes one breeze of a push to remind you,
to stretch out those wings, to hum those notes again.

Be it demons or despondency,
be it monsters or the monotony
of the motions, the humdrum of
this existence,
call them out, shout at them
in the empty, the nothing beyond where
our light shines, just further
than it reaches. Name them,
one by one with shaking fingers
and sound the alarm
for us all to come running,
let us point, let us name them
too.

You are not alone in this fight,
we will raise our fists
against the emptiness
you swear is growling,
Though we may not see them,
we will surround you
against the monsters that come,
no matter the name
they carry.

I can't sort these
hands out,
can't train them
to reach back
through cobwebs
of time
and grab on to
the shirtsleeves
of those I lost,
grab the shoulders
of those
that left of their own
accord.

What worth are these
words
if they cannot fly off
like prayers,
transcend this time
this place,
and sneak into ears
of those that most need
the comfort?

Hands and words
and both keep
coming up
empty.

Aren't we all staring
into space?
Aren't we all alone?
We're waiting on radio signals
to show us we aren't,
waiting on a sign
that there's something else
out there,
that there is more
than this.

We take our own lives,
lost and empty,
surrounded by people
that feel the same,
all wishing they weren't
so damn
lonely.

We never know the time
we are given,
we never know
the fleeting magic of our lives.
All we can do is hold tight
to those we are
lucky enough
to share it with,
breathe deep with appreciation,
and stare out with
perfect wonder.

There's something they don't tell you about adventures,
about long journeys, about exploration. It's that it's heavy.
Each new place, new sight, smell, each new turn around
a foreign corner drops a gram or two of joy into the pocket folds
of your heart. Your strength grows as you wander, you don't notice
the weight. Sometimes, before your heart knows to grow to
hold more, we weep at the excess when we see things that steal
our breath. We forget ourselves and swear, often out loud,
that we are home. Inevitably, though, we must return to the home
we left behind, and this is when it happens. All that weight,
all that mass that joy possesses, all that our hearts collected
no longer feels light at all. We lie in our own beds, stare up
to ceilings that feel lower than they ever have before, and we feel
our hearts sink below our spines, too full for our mattress to hold,
for us to understand. All we have seen, all we have felt,
all we now understand becomes a brick of an anchor,
and we ache to keep filling it. We ache for the wild journey
we left behind. We miss the spontaneity, the map sprawled out,
the newness of each morning. We miss feeling new, ourselves.
It's heavy, wandering off into the unknown, it's heavier still,
coming back home.

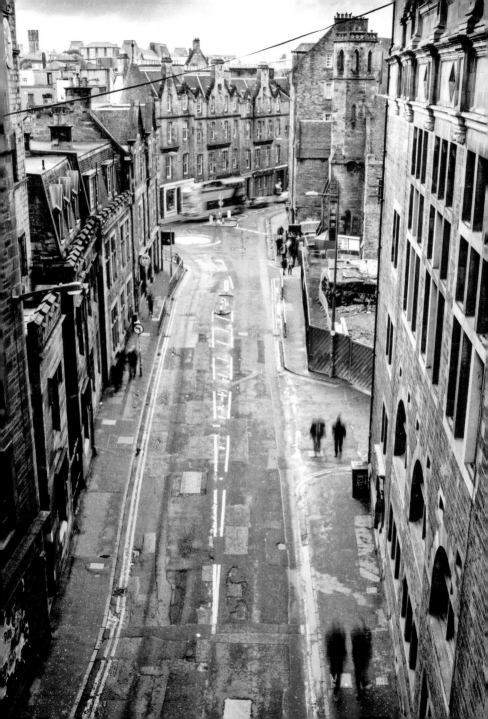

I am so heavy
with hope,
bloated and bogged down,
what a burden
to carry.

Buckling knees
under the weight
of wishing,
spine like a
question mark,
but belief
like a
period.

You aren't stuck
you're just not there
quite yet.
You aren't what you're
going through,
not the trials or tribulations,
you aren't the failures
or the exhaustion
you feel.
You aren't the broken down
or the battered,
you are beyond
what you're enduring,
you're bigger than those
that try to break you.

You'll get there,
whole, though there
may be fractures.

You aren't stuck,
and your story isn't
over.

This hurts, I know,
pulls the stitches apart inside,
tears them and leaves
the residue of the blood
you lost,
but it will pass, it will
slow.
Remind yourself
all the times it felt too much,
all the times you
could have given up.
You're here,
now,
and this is how I define
strength.

Are you overcome,

are you aching?  Do you feel

the light fading, the

ink of loneliness cascading off the walls,

painting shadow onto the life you built?

Know I have too, know that I know

this darkness.  I will not patronize you

with promises of sunrise, but I will tell you,

nothing in that paralyzing night can touch you,

nothing can hurt you.  You are

all the light

you

have ever needed.

Buried in smoke and ash,
old whisky and cheap gin,
Bukowski hid a bluebird in his chest,
ashamed of the song,
perhaps, ashamed that he loved it,
maybe. Stuffed down and clipped wings,
is a bird a bird
if you don't let it fly?
Strength like armor
never made to fit,
bravado can't stop a bullet,
can't stop you
drowning.
Shame, this,
who knows where wings
could take a man,
who knows how things look
from such
heights.

Such a god damned rush
to be something else,
not a moment's reflection
as to where we've
come from,
how much we have
changed.

Harshest critics,
we are,
sternest judges
with strongest fingers
that only know to point
backwards.

Slow on down child,
you've nowhere
to be,
you've no one else
you need
to become.

Here's what I think:
You gotta be what you are, and you gotta be it all the way.
You can't worry about what people think of you on this path.
You have to love completely, everyone you can,
everyone you choose to let into your life.
Pay no attention to those who tell you that you must guard
your heart, for in protecting yourself against sorrow,
you insulate yourself from so much joy as well.
Take time to breathe, not the shallow breaths we have all grown
accustomed to in our busy sprints through this life,
but deep belly breaths that refill all we lose.
Practice an art, any art, it will stretch your capacity for curiosity
and compassion and creativity and make you better in a jillion ways.
Drink water and green tea, often and more than you think
you need. Hear, and what's more, listen, truly.
Be a source of comfort to all you can, a safe base,
a time-out in the game of tag we call life. Give and give
and give and give and marvel at how full you feel.
Find joy, and if you can't, create it.
Take care of your body and let it carry you deep into your years.
Love. And love more. And when you are loving,
fall even deeper in love with what it feels like to effortlessly
and automatically put someone else before you.
It happens silently and feels more like home than any fairy-tale,
grand-romantic-gesture, movie love ever could.

Some drudgery, some stiff shoes
some aimless shuffle down some
crooked sidewalk,
some point to this, they say,
some character  built, something
about putting your head down
and working for some future
shining in some distance,
some promise they say
they'll keep.

One to part the crowd,
to swim upstream and disturb
the universe,
one to walk against,
some outburst of color
in some ocean of grey.

We know nothing of tomorrow,
we know empty hands
when reaching for days to come,
all we have is this,

all we are is
now.

It's curtains in some summer breeze,
it's steam from tea just steeped.
It's first steps on foreign soil,
last steps into your own bed,
it's pretending to haggle over price
then paying more than they asked,
it's voices in accents not your own.
It's sea mist and it's mountain air,
it's cobblestones and it's the shadow
of some ruin on some hillside in rainfall
and fog.
It's being lost, but never feeling like it,
it's being found, and feeling like it.
It's lamplight and peat smoke,
it's feeling right on the wrong side of the road,
then feeling wrong, on the right one,
it's exhaustion painted with bliss,
bliss stained with peace that comes only
when you're away from the things
of man.
It's the whisper of the distance
it's the rumble of thunder in a sky
you've only just met,
it's the discoveries, every single excavation
of every single buried artifact in yourself,
it's the wiping off of every grain of sand
and dust that settled in your stillness.

It'll come, it always does, this darkness you swear you cannot beat.
It'll drip across all you see, stain the world in shadow,
in night. You can join it, fade into nothingness and the empty,
or you can raise your flame defiantly against it, you can scream
over torch fire and smoke. Throw your glow recklessly
into the dark, let them see you smile in the half-light.

.

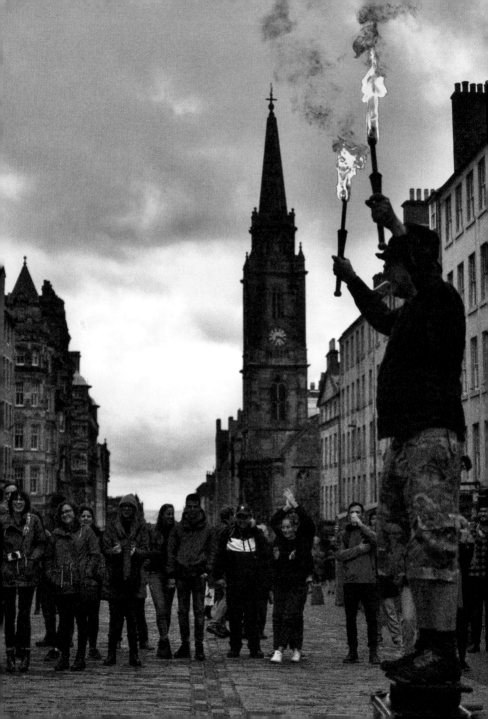

Heated like steel,
plunged into the flame
of my own life,
the burning I hissed
against.

Thought this would melt me,
these years of forge
and glow, thought
I would be molten
and drip to floor
of dirt and straw.

Then came the water,
the triumph of steam
when cold found my
heat.

Were it not for those
flaming days,
I would never have
transformed.

If pain is a cleansing thing
then I am baptized, new,
then I am fresh
and unadorned
for you.

Some hands are healing ones,
place themselves on
the surfaces of our scars
and send out soothing
in waves, in pulsations
of stillness. I feel your skin
on the raised flesh of me
and a quiet comes.

If pain is a cleansing thing,
then consider me infant,
newborn, staring at you
with eyes soaked in salvation,
in devotion.

Tomorrow, more than today,
and now, miles from
all I carried for you
yesterday.

What is left but to fear the worst of us,
what more than to dread the
coming tide of humanity, the unrelenting
waves that wash away everything
that came before it?  Shall I hold hope,
fragile handed and hands cupped at breast,
an offering bowl I carry silently and alone?
Would the dust covered survivors
laugh at that burden?  Would they stare
and point through cracked glasses
and lick their parched lips in curiosity,
would they think me crazy in
incurable ways?

I was born a wild thing, compressed
down to fit inside skin that still
doesn't feel as though it fits.  I've spent
years stretching and testing its elasticity, filling
it with wilder dreams and a heart stitched
back together with slim threads of
hope.  I am bursting at these seams,
and beams of light are
escaping.  I have no fear
for the worst
of us.

Maybe I'm stubborn,
maybe I'm
crazy,
but for some reason
I cannot shake
the hope
from this old heart
of mine.

Hear me, mark these words as truth,
you, all of you,
you broken bastards, you forlorn lovers,
you who sail seas on ships that you know
will sink, you who wait for midnight
to finally stop squinting, you who
give until empty, and then scream out
that there's still more for the taking,
for all those that know only taking.
Listen you, you fractured lot, you who wish
for disease, for a distracted bus driver on a
busy street, you who want to give up
but don't know the ways to, you who
do, but stay anyway, Listen, hear me
and believe.

Lean in, trust me, you soul sick and
worn out wanderers, you shivering
birds, wings quiet for too long, looking for
love and hands to hold you and
something beyond this single serving
sex as a transaction society,
open your ears to me, hear this whisper
and repeat it like a scream:
you are loved, you are loved,

you are loved.

Something bigger than this
is waiting for you
to find it.

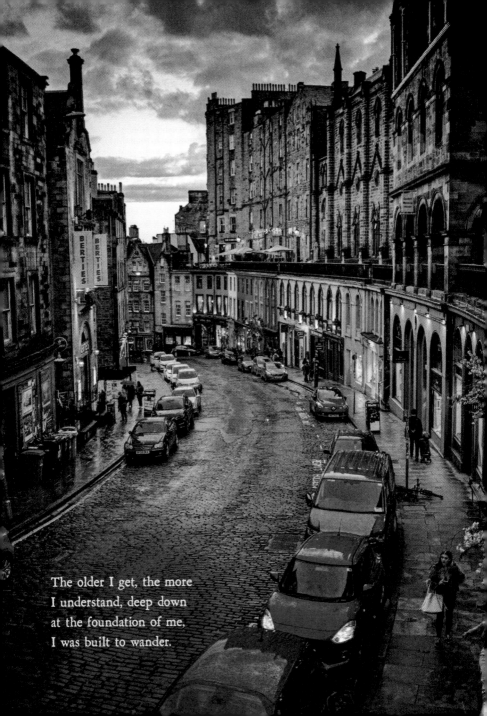

The older I get, the more
I understand, deep down
at the foundation of me,
I was built to wander.

Does it burn you,
does it spread flame
inside?

Touch it, again.
Let it consume
you.

This is the Why
you were
after.

THE DOCTOR

There's a cost to become yourself,
a price you'll pay,
in people trusted once,
people who loved who you were
but feared who came next,
the evolution of you.

Savers, we, holding on to hurt,
those who hurt us,
saying we're too poor to give them up,
saying we will take
what we can get.
More, they take, more
we're left empty
but emptying pockets.

This is a cost you can bear,
cut off the cord
and say goodbye.

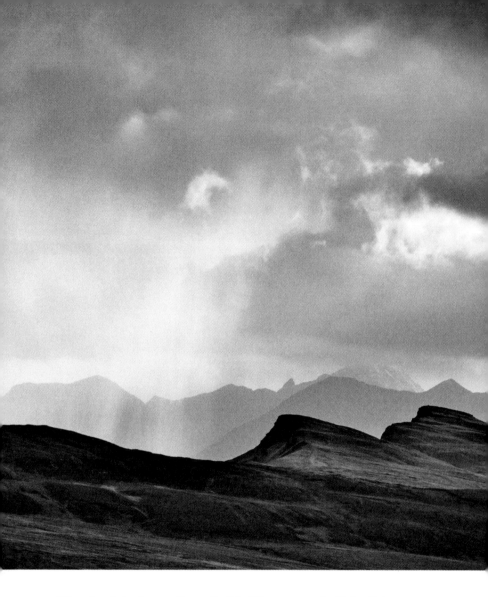

There's a lot of ways through this life, you can hold it all in,
hoard it until you're too swollen to save, or you can pour it all out.
I think we are born for the storming.

With paint and ink
with sound,
some fury as blood
finds bag and knuckles
split,
I seek to define
this aching.

Some things
feel like nothing
but themselves,
no more, though
we try to spread them,
to dilute with
false understanding.

There is noise,
always there is
so much clatter
and din,

all this is, is me
trying to
explain.

Only what's real,
what's torn and ripped
from the pieces of me
I don't know the ways
to hide.  Only what's true,
what's been earned by ache
and sorrow and some form
of unrestrained joy that came
after I learned all there is
of longing.
Take the bite sized and saccharine
slop and set it alight,
burn it down and use the ash
to write something honest,
something worth it, something
that hits like a fist and stays
like a promise.
What are we here for if not this,
why bother if it's not
stained in our
blood?

It changes us, if we
dunk our heads
in it,
this churning pool
of a planet,
it shifts the molecules
and rearranges
how they cling to one
another.

We are children
on riverbank,
told to bathe,

the water is wide,
and if we let it
the current
will carry us
away.

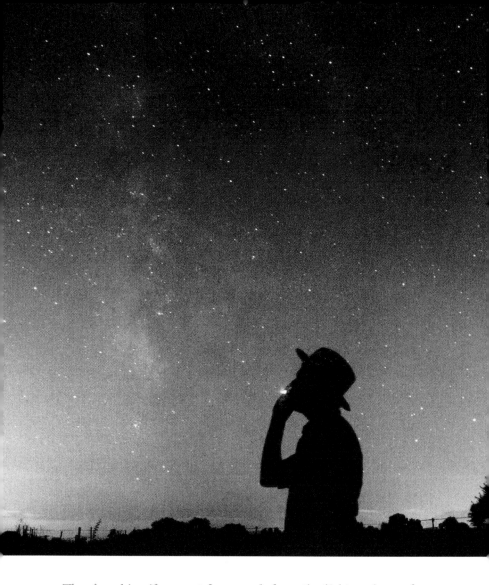

There's a shine if you get far enough from the lights we've made,
there's a shine in what we called nothing. There are pinpricks
in the curtain, and we can see them if we stay still. Run off,
and give yourself to the glow.

Show me your teeth bared,
show me claws out
and fists up,
show me roar and scream
show me fire
that rises from the center
of you.

You have endured enough,
it is time to rise,
face what knocked you down
and dare it to try
again.

Would you wallow there,
there with face in sand
and breath choking
on sea foam and
salt?  Would you
turn, and show
your back
to the fear?

Stand, brush yourself
off, and raise your
fists
to the air.

I need not book
nor cathedral grand,
I need not psalm
or knees that kneel.
Keep your robes,
your staff and grail,
I need not the organ
or glass stained
with story.

Give me mountain,
give me sea,
give me starlight,
give me tree.

One hundred steps
into some far off
wild,
and I know all I need
of god.

There were wings before,
we carry no scars
where they used to be,
forgotten
as we metamorphose
in reverse.

Started as holy things,
we,
though some say
we've lost all that.

There is time for flight
again, if we can lift
one another,

and if nothing else
we can trace our fingers
where wings
once were.

Broken pieces of broken bits
all threat to the barefoot
of the world.  I think I
shine in the sunlight,
half pretty and glinting
but I cut, deep,
without ever meaning to.

Be the ocean and the stones
it carries, toss me
and roll me and smooth
all that jagged edged
nonsense
I became when shattering
replaced shelf sitting.

Make me sea glass,
finger held from stooping
hands, make me worthy
of saving,
of some pocket,
somewhere.

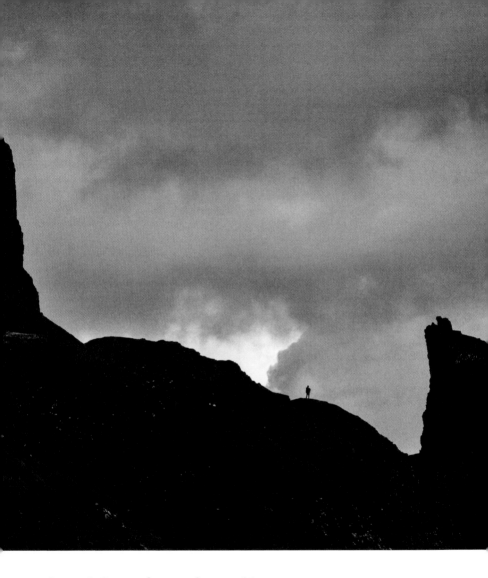

Strength from endurance, from pushing up
when slammed against, from rising into the fog, into the ether.
Strength from the patience to wait for what you'll become.
From pebbles we begin.

Do not forget that even
the trees
shake the snow off their branches
from time to time;
do not forget there is no shame
in refusing to carry
a weight
any further.

In place of predetermined
I want possibility,

just the hinting chance
of something magic,

an aim for this hope,
a reason for waking up

and trying to do better,
trying to feel more.

Give me a fleeting chance
and tell me it may not be

possible, and watch as I
run straight for it.

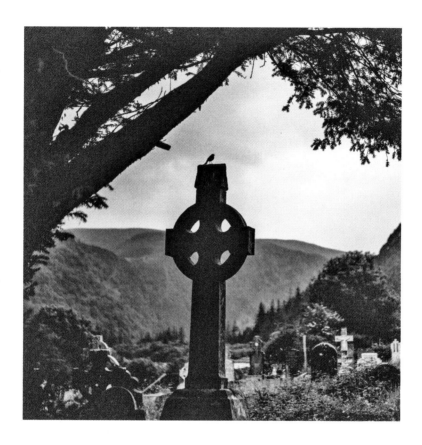

Life is fragile and sweet and fleeting and strange and hard
and gorgeous and cruel and kind and joyful and soaked in sorrow.
We are here mere moments before we begin again.
Celebrate every second you draw breath, and then, when breath
comes no more, celebrate the starting over.

Much was learned, over the course
of this life, from days of sun,
of calm, of peace possibly unearned,
possibly only partially deserved.
In a million ways
I was shaped by the happiness
that found its way in, but, and isn't
there always a but,
much more was learned
from the tumult,
from the storms that never
seemed to quiet, the thunder that shook
the bones beneath me.

What I am, was lightning forged
and earthquake stirred;
I am the consequence of
chaos.

Quiet
from time to time,
soft and off.

Sometimes,
I say,
you have to clean
the house

before you open
the door.

When the rains come,
and mine came early,
all we know of earth
dissolves.

What are we
before the storms?
What was I
before the mud?

In the quicksand of
my sorrow
I told myself I was born
for sinking,
who can hear my shouts
over thunder loud
and lightning bright?

All I knew of earth
dissolved and made liquid
when the rains came,
and mine came early,
before the storms I was this,
always this,

and now I run through
the mud that once sank me,
I bathe in it like baptism
and stand, white teeth grinning
through dirty face.

Over thunder loud
and lightning bright
hear my shouts.

The end is coming, I sense it bubbling up
like a caldera still alive and pulsing with life,
still ready to restart this chaos we call
civilization.  I sense it like early warning
earthquakes and livestock lying down,
huddled up against a storm we still can't see,
blue skies bluffing and convincing us otherwise.
Death is knocking, like a moth at the door,
like a raven perched at the peak of this house,
a sparrow flying through your open window,
it's here and we just don't want to see it,
turn our heads and hope it goes away,
pull the covers tighter around our heads,
hide until we think we're safe.

This false Shangri-La, this curated museum
of falsehood and phoniness.  Here,
ten thousand photographs all the same,
here, ten thousand cliches repeated,
in ten thousand ways, the same words recycled
and regurgitated and spit back out.
Somehow we became infant birds, featherless
and naked and screaming for more,
somehow we lost sight of the horizon line.

Let the end come, let the ash cloud from this
eruption cover the blue light glow we call sun,
let it paralyze our thumbs from mindless double
tapping on glass and battery.

Restart.  Give us sticks and soil
and let us write again.  Let us gather
around and in some warm firelight
finally feel understood.

Felt home there, but not
in a way I'd felt before.
Not home as comfort, not as
a place familiar, not home as
safety, not complacency or
contentedness, home in a new
sense, home undefined.
That place was a peace
unexpected, a soothing
to the soul sickness I'd carried
all my life, that place was home,
but in a way I haven't invented
words for, haven't even Learned
the vocalizations to.

Somewhere in the fog and grey,
in the green that wraps all things
and leaks into the red of your blood,
a question I didn't know
I have always been asking
was answered.

Here, it whispered, the sound
hovering above snaking road
and hillside  here, said soft
and slow in the heather and moss,

you are home.

I am not perfect, never will be, but I'll be damned if I am not trying. It's noisy in here, a constant hum of sounds I cannot quantify, cannot partition out and selectively silence. I am a sea soaked in storm sometimes, and certain days are spent gripping the handrails of this ship, riding out the swell and telling myself the horizon will settle things. I am trying. I'm a voice before a deep breath, sometimes, passion rising up in this throat, but it's love that raises it, like some forgotten flag on some forgotten flagpole deep within me.

These are your colors I hoist, this is your fabric that flaps
and moves in the wind. Do you see that, do you know? I am trying.
I am a mountaintop in a misty morning, sometimes, the peak
obscured, but calling out. It'll be dark, but I'll keep walking,
I'll find my feet one after another no matter the grade,
no matter the load I carry. I will summit, I will disappear into
that foggy curtain and come down the other side. There is light,
there, and I will seek it. I am not perfect, never have been,
but I'll leave these fingers crossed that you know I am trying.

The illumination of what
is vital, what matters
when pushing becomes
shoving.

Thought it mattered,
the car we drove, the clothes
we wore, thought
it was the wealth we chased,
the accumulation,
mountains of shit
that overflow into garage,
into back closet bursting
at its hinges.

Took losing to know,
took an entire planet
gasping for air
to show us the truth
we'd lost sight of

it's people, it's
reaching out and holding
on to another human being,
it's arms around arms
and it's hands in hands
and it's the hundreds
of friendships
we didn't even know
qualified as such.
It's us we miss,
the collective We spread
out like wildflowers,
all waiting once again
for the rain.

I imagine them hidden, just beneath the surface
of my skin, veins are roots, and the leaves
just haven't found their way out yet,
just haven't seen the light.
More tree than man, beneath all this,
taking the poison from you,
transforming it back to the air
that keeps you breathing.
I wonder if you know how often
I stay quiet
just dying to be watered.
I swear when the wind picks up,
breathless in some forest,
I can hear them whispering.
Beneath all I am, I know without question
I speak the language
they speak.

More tree than man, chasing
some light, reaching
through the darkness that
can surround me.

Art in the pouring,
coffee in the morning.
In the waking,
feet to floor to stairs,
art in the breathing
when you may not
wish to.

Art in the letting go,
refusing to carry.
In the washing of ourselves,
dirt like landslide
into drain.
Art in the standing
shivering cold and raised skin,
steam rising
volcanic from hair,
from shoulder blades,
from hips and
hands.

Art in the starting over,
eyes closing
with no promise
of tomorrow.

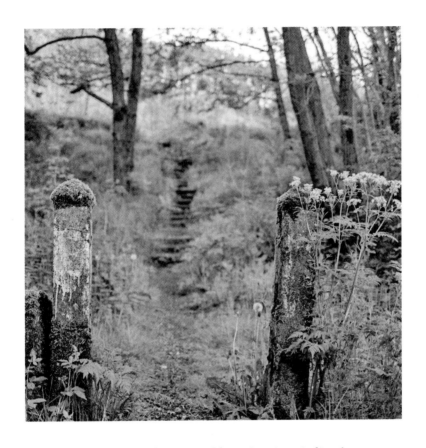

Here's to the dusty roads, the muddy paths, the winding lanes.
Here's to the far-away, we're-not-in-Kansas-anymore-Toto adventure
through this world. Here's to the way we feel when we are worn
out and broken down and more alive than we've ever been.
Here's to it, see you out there.

I wish for backwards, ferociously I wish for it,
a rewind of time, a finger on the hour hand
spinning further and further,
the number in the date window of some watch
counting down then starting over as the month
backpedals, as the years fall away.
I wish for backwards, on and on until
buildings are un-built, a story at a time,
railroad tracks lift like stitches removed from
the wounds we caused. I want to see
contrails wisp away like they were only clouds,
I want to hear silence where highways
once rumbled, I want to rise up and see
how rivers knew the way to the sea
before we knew to build dams to stop them.
One by one I wish for the extinguishing of
electric light, like magic called out before
Tesla fought a desperate war for which current
we'd choose. Like candles blown out,
I want to see the darkness reclaim itself,
watch the stars grow confident once again,
burning like they knew to burn, like they still burn
only we cannot find them in the orange haze
of our progress.

Feverishly, I ask each night for the brave call
of retreat, for a cinematic reversal of all that's come,
sped up for brevity's sake, I ask for us all,
fumbling fools in the dark,
looking for a sliver of light to share, fresh,
flawed but hopeful, waiting for a single spark
to warm us in the night.

Minerals and air
and we call this
a body,
call this a life.
Minerals and dust
from some cosmic
explosion,
and we wonder
about magnetism
and what pulls us
to one another.

Aren't we starlight
faded and forgotten,
aren't we looking
for just one more moment
of shine?

Mornings will be silent, evenings too,
and there is no avoiding this.
Where birdsong was,
noiselessness,
and this is what will be.

Three billion birds in under
a century, up and off and vanished,
and none by the power
of their own wingbeats.

Gone, and with them goes
the songs.

"This is a loss of nature,"
a scientist says with what I imagine
are tears in his eyes,
and stares straight ahead,
through that strange quiet place
that comes with disbelief.

I want no part of a birdless world,
I cannot fathom the depth
of that emptiness, that silence.

Soon, there will be nothing left here,
but us.

Are you morning, are you light,
are you the shine of hope,
are you the promise?

Am I the night, the deep quiet
between the stars, am I
forlorn, melancholy and
memory as it falls apart,
am I the fragments?

I am the table side
of the coin you've been,
the earth buried root
to the branches of you,
where you shine
I absorb,
I offer less heat,
I know this,

but you will love
my gravity.

I love how light fades away at close of day,
clings to every last thing it can to linger just
a half second longer, then sighs, and lets go
gentle as you like, and evaporates. Oh could
we be more like light, hold tightly but let go
when we know it's time, fearless, soft

Threads, always we've been threads,
some strong some frayed, some vibrant
while others soft, delicate in their shade.
Woven, we, this around that around this,
lives like string, like a soft tug could undo us
or pull us closer together. Pulled,
every single piece changes, what happens
to you, will happen to me,
somewhere down the line, be it hours,
or moments, weeks or the passing of
decades.

Pass down this truth, over old hands
held to old lips, across creases in fingertips
worked to bone, pass it down over tea steam
and smoke, pass it to those who forgot,
those who never knew.

These threads tell stories, yours, ours,
tell of survival and ferocious tenderness
in the face of it all.

Pass down this truth, pull lightly
on these strings, show us what it is
to come together.

We're a species that hides our faces
in laughter, in tears,
ashamed to show the edges
of emotion.
Safe there, in the middle,
half alive but without the need
for all the apologies
we never needed.

Sink into the borders,
that's where the answers are,
that's where life
begins.

Grace
is born
in longing,
strength
in quietly
refusing to settle.
Do not give up,
light lives beyond this,
growing brighter
in the darkness.
One day,
you will forget
the shadows
you once called
Home.

Hold,
please hold on,
for in the waiting
there is
Hope.

Enough luck
and we're a living thing,
pulse of blood or patience
of photosynthesis,
enough time
and we call it a life,
wrinkles on flesh
or rings around rings
that tell our story.

Somewhere between them,
scars stay,
what we've endured
and incorporated into ourselves,
what we've seen
a line amongst lines,
lost to everyone
but us.

And in some far-off place,
some great stillness will grow.
From fallen things half a gust
from decay, from worn-out
wood a whisper from dust,
you will find the beauty
you have sought. You will
have your peace.

To hell with beauty
or what they teach us
of it, to hell with thigh gaps
and legs too thin to run on,
to hell with wasting away
for magazine covers
or movie screens, to hell with
trying to be less
to feel like more.

Give me strength,
give me ferocity of soul,
give me courage to be
who you were born to be,
the comfort that comes
with loving every piece
of yourself.

Call this exorcism, call it
the casting out of every demon
planted by every demand
this world has placed
on your body.  Scream with
strong arms and legs,
scream with your refusal
to waste away.

This isn't what moonlight
was made for,
not painting rooftops
and building walls, not
drowned out with streetlamp,
with car horn and
hustle.

Moonlight is for sea,
for endless fields of wheat
in soft breeze,
moonlight is for dirt road
and dark tree on
horizon.

Moonlight is for hands,
for silence, for crunch
of earth underfoot.

Seek the silver away
from the gold,
away from the glowing
pollution
we send into the heavens,
away from all the lights
we never put
out.

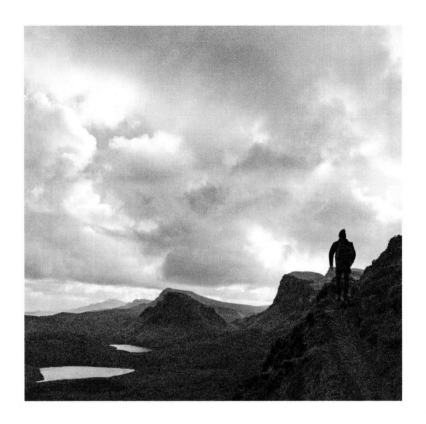

If you know the shadow, seen behind the veil, felt the dark pools
humming your song, if you've felt the cold run up your spine,
call itself friend on your shoulder and heard its whispers
in the silent moments, you'll understand . . . when we walk into
the light, there's still a gloom behind us. It still follows.
Aim at the shine and don't ever stop walking.

If the shadow keeps catching up to you, know there is help,
know there are ears and hearts and souls that care, that will help.
Reach out.

I told myself there was light within,
bursting around my organs,
saturating blood in glow.
I swallowed a sun, or a moon
at the least, I said when things felt
dark, it's there, it's there.

Gave pieces of myself away
to let it shine out, dozens spread
to dozens needing, called them
constellations when I imagined
all those beams landing
in all that night.

Never saw that light,
but believed it all the same,
just felt better thinking that after
all I gave away,
some warmth remained.

You'll find yourself a speck
on a shoreline, lost with tide
scratching up the sand.
You'll feel empty lunged and
searching,
I know this, I can promise it
with confidence and trace
of sorrow.

Sometimes you will roll over,
away from what keeps you
awake, you think to yourself,
but the face of it will follow,
it will sigh as you sigh,
sadness, it is patient this way.

One day you'll wake,
I can promise this too,
and only your pillow will have
an indentation. You will
breathe deeply again,
you will forget the sleepless hours,
the waves of ache
that never stopped coming.

I am sad, a lot, but still ferociously strong,
not sure where the melancholy comes from,
but I'm in the middle of it, often.
There is no weakness in heavy hearts,
I've never seen it as an anchor, but a
rudder on the high seas I'm sailing,
I trust where the wind goes, but sometimes
I have to steer away from the swell,
sometimes I have to hold the rails and ride out
what I can't stop coming.

See these hands, they are sea worn and strong,
altogether familiar with salt and its drying
on their surfaces.

I am sad, a lot, but happiness abounds,
both exist, both spend time at the helm,
and this is ok.

There is no wrong way to stay afloat.

Will the end come too early,
will disease spread in me,
virus or ache like roots, will they
blossom in ways that bear fruit,
will I go before I wish,
before I have said what I
should say?
Will I lose you, will you abandon me
on this bright surface,
will your leaving set it dark,
set me the same? Will you
vanish before I build a home in you?
This is a construction
that will never stop,
so you too must never
stop.

There is nothing in this worry,
no need for the weight,
we will go when we will go,
and so I set myself
to hammering.

Stand up, scream if you've got voice
left in your lungs,
write it bold on signs and wave them
if you're already hoarse from
shouting.
Fight dammit, fight for
what you believe, for those you love,
for those who are paralyzed by fear
or the weight of circumstance,
fight when their backs
are against the
walls.
Stand up, scream,
fight, for if you're not actively defending
what is right,
you are passively contributing
to what is
wrong.

Pulled to transparency,
stretched until fibers torn
and clinging
at their ends,
anchored to tired heart,
to worn out legs.

Half here,
most often,
here at the mooring,
pulse like a tide
steady and heaving,

there at the places
that stole pieces
of this soul,
the other half,

my god how hard
it pulls.

No such thing as
prepared,
your heart will shatter
and every single
piece
will reflect back
your sorrow.

This is coming,
has before,
will again.

But

slowly, like some
tender sprout,
hope
will grow.

If there are flowers in you
send them out, explode
with color and grace;
waste no sunlight, no time
in the hiding.
If you're made to bloom,
bloom.

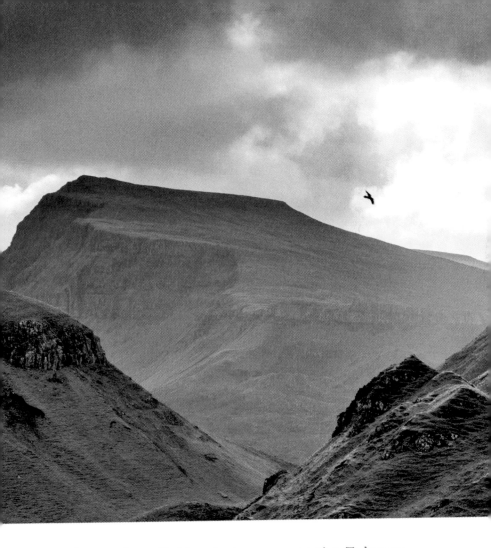

To fly, soar above all this and gain new perspective. To become untethered, to look down and realize how small we've always been. To trust our wings, to remember what we were taught of flight. To brave the fog and wind, the stone and rain, to exhaust ourselves in the pursuit of gleam.

You were not made for me,
but for you,
you for yourself,
it has always been
this way.

Never have you belonged
to anyone else,
not for a half moment,
not for a long blink
or whatever splits
the difference between
our measurements
of time.

You are yours,
the key and the lock,
the handle,
the door, the window,
and the wall.

You are the house,
the home, the only one
who can ever offer
invitation.

Stick and bird
me the first
you the latter.
I the support,
branched out,
holding,

you the feathers,
daughter of wind,

hollow boned
and shining.

I'll be here,
stillness for the
landing upon,
here,
when your wings
need rest.

Stick,
and bird.

Split us, with mountains,
with continents of grassland,
with rivers, with time.
Split us, with hours and aching,

with months that hurt in ways
we couldn't imagine.
Split us, with whispers
and sorrow, with a wait
that buries every seed
of our hope.
Split us, with shadow

and storm, with tumult
and the confusion born
from unheld hands
and unheard laughter.
Split us, and watch us return,
heal like a wound given hours
and the aching.

Watch us grow like sprouts
from buried seeds, triumphant
though sunless. Watch us
find home, across mountains,
across continents of grasslands,
over rivers.

Over time.

*do*

Forgetful lot,
we,
misplace the knowledge
that we
are still alive,
still beating heart
and rebellious
breath.

Each ache
is not the finale,
each twinge
of each piece
inside,
not the bell lap
sounding
before we
cease.

Soak your fear
in the blood
that thumps,
wring it out
and drip
maroon

everywhere
you
go.

Broken people are metal and magnet,
all the cracks filled up
with smelted remains of old survival,
recycled, candy swirl over flame.

Magnets in the fingertips,
drawn to one another,
something sticks when one
finds one
and we call ourselves
ferrous.

Broken people find broken people
and spend their dim hours
tracing out all those fused places
of ache.

And sometimes,
if you wait long enough,
if you hope hard,
the dark clouds open
and light
pools out defiantly
once more.

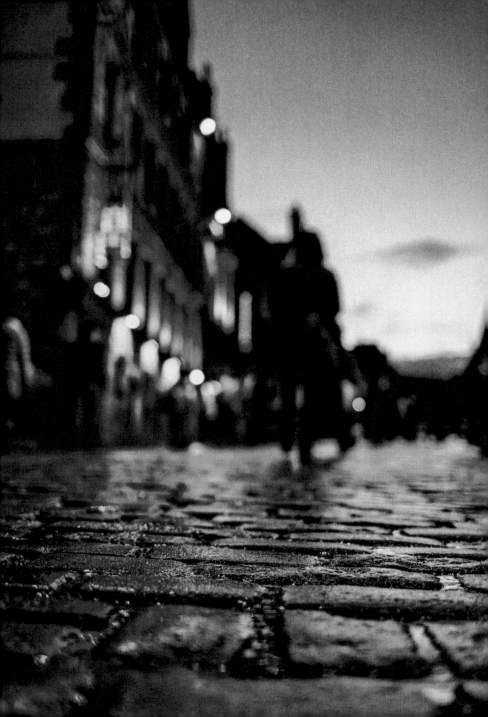

Moments. A million moments all add up to make a life.
Do what you can do to make sure that, scattered about in all yours,
there are moments that take your breath away.
That remind you how unbelievably lucky we are to be alive.
That connect you to the rest of it. Moments, that's all it is.

One day you'll understand
the purpose behind
the suffering, the struggle
you swore would undo you.
You'll see,
standing proudly
in the untangled ribbon
that you wrapped tight
to hold yourself
together,
the picture painted
with the deep maroon
of the blood you
spilled.

I swear to you,
this process will hurt,
there's no getting
around this,
there's no avoiding
the pain that will come,

but I swear to you,
it will pass
and when it does
you will have
your answers.

Out into the shadow places,
the blue hour
before nightfall,
half a second before
wild things that call
in the blackness.

After the explosion of light
and color into the far off
mountains,
beyond the sun splash
over the surface of some
stormy sea,
when all that remains is the
soft cyan glow behind
the grey clouds,

you will see me,
silhouetted and growing
smaller,
as I vanish
into the perfect
nothing.

You

You can paint it as you wish,
but sadness,
is a monster of a thing.
There is nothing romantic
about being so low,
there is nothing beautiful
about wanting it all
to end.
If ever
you should find yourself
here,
scream out, holler
until someone comes
running.

Ancient together, promise me this,
shuffling and lost. I want to stand
hand in old hand,
and stare out at a day that passes,
help you rise from sofa, from sleep.

You will grow forgetful, but not of me,
and I will remind you, until
in some haze of some dream
we are united in amnesia again.

Drink, I tell you, pills in hand,
Eat, you whisper, appetite less,
as remembering burns so few
calories. Sit with me, here,
by the window light,
there are birds to see,
don't you remember flight?

Let us be ancient together,
promise me this,
two trees, we,
roots through floorboards
through basement, through foundation
and bedrock.
Bristlecone pines, perhaps,
sequoias set indoors,
call me Prometheus,
and I will sing your name
as Methuselah,
for I will go before you
will go.

Don't be a star chart,
a map of the heavens,
don't be an encyclopedia to
the mysteries in all that
darkness. Don't be
a knowable thing.

Be a meteor shower
that comes out of nothing,
out of nowhere, unstudied
and unexpected. Be a
passing flame that explodes
and lights up
the night.

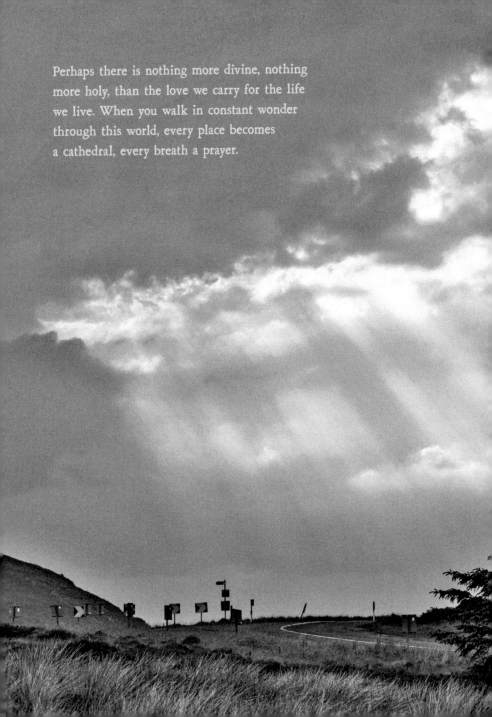

Perhaps there is nothing more divine, nothing
more holy, than the love we carry for the life
we live. When you walk in constant wonder
through this world, every place becomes
a cathedral, every breath a prayer.

Aren't we what we show,
not what we hide,
aren't we walking advertisements,
aren't we false?

What remains when it all
crashes down,
slides back into the sea
and settles
beneath foam
and kelp,

we are this,
salt soaked
but free.

# THE IRISH

## *A Character Study*

Everything blows away, in the end,
the leaves that fell, the snow
when Spring winds return,
the ashes of us on some stiff
Eastern breeze, when rest comes,
finally.

All things to pass, eventually,
and in between the kick start
and fluttering off,
life, or what we make of it.

Somewhere, in the middle
of the timeline, we are here,
shouting against the storm
that builds on the horizon distant,
daring them to disturb our hair.

If we run into it, hand in hand,
fast enough, maybe, for a moment,
we can be young together
again.

I lived there for a time, told myself it was home,
I loved there, too, for a time,
told myself it was enough. I fumbled
through this bardo, this borderland between
wake and some slowly lumbering slumber,
decorated myself with the ash
of the day that came before. It burned
to let sprout all that will come,
but first,
this.

Am I split, am I splintered, am I cut in two?
Wrapped up in a hollow place, do I have to dream
just to find you? Fragments of a man,

of a mind, half asleep and fighting to stay
awake. Sometimes, I don't know which

are stars, and which are sparks:
one warms, both shine.

Find me here, I called it home once, I can again,
find me, now, and brush the fire from my skin.
I have spent a lifetime wondering why,
I can hear the crackling of flames
just before I fall
asleep.

There's a little bit of death
in every day,
the passing of a moment,
the dying of the light,
the leaf that falls or
bee that no longer
bumbles.

Every beat of every heart
is one closer
to the last.

Cherish this life,
pour yourself out
and soak into every single
fracture you find.

Hard things crumble,
don't you know by now,
solidity
is a false sense
of security.
Look at the trees
and how they sway,

roots deep below
the earth we borrow,
but in the storms
they dance.

Be the tree
and not the stone,
and if fire comes
(and come it will)
swing back and forth
until you are ash
once more.

## Bend of
## the Snake

A naive peace

in the belief that one day

it'll all make sense.

I think we tuck ourselves

into beds made of this,

these soft sheets of some

far off time

where everything we ached for

is wrapped up sweet and tight

in the color of understanding.

What's this for if not this?

There must come a passing

to the storm.

I try to imagine, when I wander this world, what a life lived in each place would be. I try to imagine the minutiae of each morning, the rhythms of routine that would constitute a year. What sound would my tires make on this road, what would night feel like in my lungs here? Right now, there are ten million copies of me, vibrant and alive, living out a life contentedly everywhere I have ever stopped to wonder.

I wish them all well.

If I could thin the veil, stretch it like canvas
until its gauntness renders transparency,
if I had hands that knew the way to hold
the edges of that world and this,
strength to pull until overlapped, who
among the lost would I see again?

What would you say to me, grandfathers
departed and overlooking, what would you
offer in these times, would you be proud
of what you see in me, would I be
known to you, me of new wrinkle and
softer voice, of hands showing age
and the mistakes of youth?

Grandmother, are you resting, are you
safe there? Did you find peace with me
in this time we've spent apart,
we of strong spirits often on opposite
sides of understanding? Know that I
loved you dearly, that I do, still.

Friends, too many at this age, too many
by your own hands, why did you go?
I am sorry I did not know the darkness
you swam through, I am sorry
I did not jump in to swim beside you
until you admitted your fatigue and
held tight to my back. I had enough strength
to bring you to shore, and so I stand
on it, looking out at the dark waters,
listening for the sound of your voice
as waves find sand in the soft glow
of some moonlight.

I will stand still and believe in ghosts,
in your silhouette just beyond the fabric
of worlds that splits us, I will see
the indentation of your fingertips pressing
towards mine, and I will reach out
to touch them.

Sometimes it's just so much,
and I don't know anything
but the call of retreat
into the center of me.
Overwhelmed,
I call it, and fall quiet
on the outside,
Inside
it's all noise and swirl,
it's me in a river,
searching for a branch
to grab.

Patience,
is the rope you throw,
the lifeline
in the deluge.

Life can be a really simple thing if you wish it to be.
We complicate so many things unnecessarily, adding layers
of nonsense we call unavoidable, making the same mistakes
time and again as if there is no choice. We run scattered
and lonely and subscribe to this cult of busyness and priority.
Why? Slow down. Reduce. Breathe. There is more to life
than grinding through.

# HIGH TOWERS

In the frenzy,
calm.
Strength is a mast,
the spine that keeps
this ship sailing.

I was storm bound,
wind tossed and
searching,
I was asunder,
land hoping but
afloat.

You were oak,
you were sailcloth
and rope,
you were oar
and promise
that I would make it
through the
waves.

Let go what you were given
to carry,
though you were not asked,
though you were not
ready.
Forgive, though
they may not apologize,
though they may not
mean it.

Quick as it comes, it will go,
some know this,
some comfortable in the understanding
that good things
stop being them, somewhere
along the way.
With the swell
comes the crash,
and wise are those that
love both
with equal fever.

Come for the carnival
but stay for the
implosion,
the running off the rails,
the worn spot in
the grass
where the tent
once stood.

No guilt to be had
in starting over,
no shame in beginning
again.
Some will follow,
some will stay behind
and lend a soundtrack
of whispers and
side glances
when you go.

Refusing to turn around
is also
a goodbye.

When we walk a road
until its end,
stare at the beyond
for half a moment
and walk off
into whatever comes
next,

this,
is bravery.

Guide me, though you be but sliver and shadow,
show me a pathway through the dark. Hairline from emptiness,
half blink from midnight, but still you shine. Show me
what you know of light.

Buzzing like bumbles in the back corners
of a beautiful dream, I see them,
pictures of wishes, a slideshow of hopes
for all the time that is yet to come.
I see wilderness, fog rising like cloth,
blowing in the wind like drying
on the line, I see sunrise that belongs
to us all, I see dirt roads and dust
hanging in low sunbeams, I see stars,
I see so many stars. Somewhere,
growing like branches to Spring light
I see moments like leaves, flickering
into a soft breeze, pieces of a life
not yet lived. I see storms rolling
across a landscape slow and determined,
the pattern of footsteps that vanish
increasingly as they near the sea foam
and the sand, I see wind in hair and
lips curved into a smile, I see
the wild in me responding, as if primal,
as if unlearned but known, as if
a howl to join a chorus of howling,
far off beyond the treeline,
out where the darkness
begins.

I tried counting once,
how many deep breaths,
how many times I had to say
you are fine, you are fine
you are fine, before it stopped
feeling like a lie,
and started
feeling like a promise.

I do not know enough
of mathematics.
I do not know enough
of patience.

At the start, it was silence
and it'll be that again
in the end.
After some explosion
that began us, after
the blooming of light
in the stillness and obsidian,
it'll be explosion
that returns us there,
that blows out light
like birthday candle
unwished upon,
it'll be a tidal wave of
quiet and gravity.

If given wish, granted one
on the candle that'll turn
to smoke and scent,
I'd wish I could have been there,
wish I knew what
nothing made something
looked like, I'd risk two,
truth be told, as I would
wish I could be there,
there at the edge
of all things, I wish
I could peer into
whatever comes after
this.

We are all this,
something
from nothing at
all.
I wish we could stop
forgetting.

Everyone's a seed
planted somewhere
after the meeting

some are watered
with lust others disdain
some deep beneath
the soil that grew hard
and surface cracked,
some half a fingerprint
down, slight breeze
to threaten them, blow
them off before root
can take

some bloom, blossom
and seek out sun,
single flower brave
in the uncurling,

some take root
and spread,
some become
forests.

I will  not offer promises, for life spills and stains
the intent from time to time;  I will not offer guarantees.
I will not speak of resolutions,
of all that needs fixing, in all that I am.
I will not speak of where we went wrong, what we broke,
what we did not scream loudly enough for, or against.
I will not  speak of the misdoings, I will not speak ill
of those that were filled with ill will.  I will say this,
of the year that is to come, and I will mean the words I say:

I will be more.  I will be louder for truth and I will not abide
the evil of indifference or apathy.  I will lend my voice
to those who cannot find theirs, or do not know the ways
to speak loudly enough for the causes they believe in.  I will
leak gentleness and compassion when stabbed by the harsh
and tender-lacking; I will bleed beautiful and honest blood
for all that deserves it.  I will watch as these hands
hold more, and push away less, as they soothe the aches,
skin buried or soul wearied, they find in people.  This
will be a year of defiant regeneration and immaculate creativity.
A year of letting loose the tightly wound in me,
the delicate uncoiling of things long ensnarled around
this quietly beating heart.  I will be more, and I will strive
for nothing short of **illumination**;  the bright shining of light
into the darker spots in me, but more, I will strive
to shine that light onto everyone who feels theirs has gone
out, all those that forget the stunning shine of their own
spirit.

Come now hours, come days and months, come and
settle the storm we've been enduring.  Come,
and with you bring
relief.

# Acknowledgments

First, always first, thank you to my wife, Sarah Linden Gregson, for somehow being the rock that my waters crash against and the sea that soothes me. Thank you for traveling this beautiful planet with me, and for grounding me in ways I would be cloud-soaked and lost without. Thank you for what you teach me of kindness, for what you give, for the grace in the ways you let go. Thank you for you, for trusting me to stand beside you, for being my northern lights, dancing in emerald in every sky I see.

I have said it more than one time, but I am truly made of all those I love, and who, for reasons that still astound me, love me back. Here are a few who deserve to see their names in print:

Thank you to Henry and Adela: I'm doing my best and you two make all that noise a joyful thing. Thank you to Jan and Goose, who raised me and never, ever stopped letting me be the only thing I knew how to be. Thank you to my sisters, McGraw and Rian, and their wonderful husbands, Patrick and Wes, for growing this family

into the most hilarious and loving tribe I've ever heard of. Thank you to Deb and Mike for adopting me into your family, as odd as I may be.

Thank you to Edgar and Yenny, for redefining positivity and showing me that some truly become forests in your life, without ever seeing the seed buried. Thank you to Greg and Jess, who have been there since the start and never faltered. Thank you to Ash and Sav, for being a constant source of inspiration and laughter. Thank you to Gregory Alan Isakov, for being my brother since the beginning, for writing the songs that inspire me. Thank you to Pete and Lisa, who have stayed family almost a decade despite a continent between us.

Once more, I wouldn't be here without you, so thank you to my agent, Rachel Vogel, for being the voice of reason, fighting for me in ways I could never do, for sticking by me all this time. Thank you to Lauren Appleton, Marian Lizzi, Meg Leder, John Duff, Farin Schlussel, Casey Maloney, Lindsay Gordon, and everyone else who hides behind the scenes at Penguin Random House and TarcherPerigee. You let me do what I love doing, and I am in your debt, always.

Finally, thank you to everyone who follows, who reads, who supports, who reaches out, who believes in hope as I do, and who has stuck around through this whole crazy thing.

Three thousand some days ago, I embarked on a journey that at the time seemed fleeting and temporary, a distraction to get me through those last months of winter that never seem to leave Montana, stretching into and stealing our spring. Three thousand some days ago I began, and here we are. Who knows what the next three thousand will bring. I hope you'll stick around.

# About the Author

TYLER KNOTT GREGSON is a poet, photographer, artist, Buddhist, and author of the nationally bestselling *Chasers of the Light, All the Words Are Yours, Wildly into the Dark, Miracle in the Mundane,* and the children's book *North Pole Ninjas.*

When he's not writing, he operates Chasers of the Light Photography and photographs weddings and travel all over the globe with his wife and partner in general mischief, Sarah Linden Gregson.

chasersofthelight.com
@TylerKnott on all the social medias